Plymouth's Forgotten Prodigy

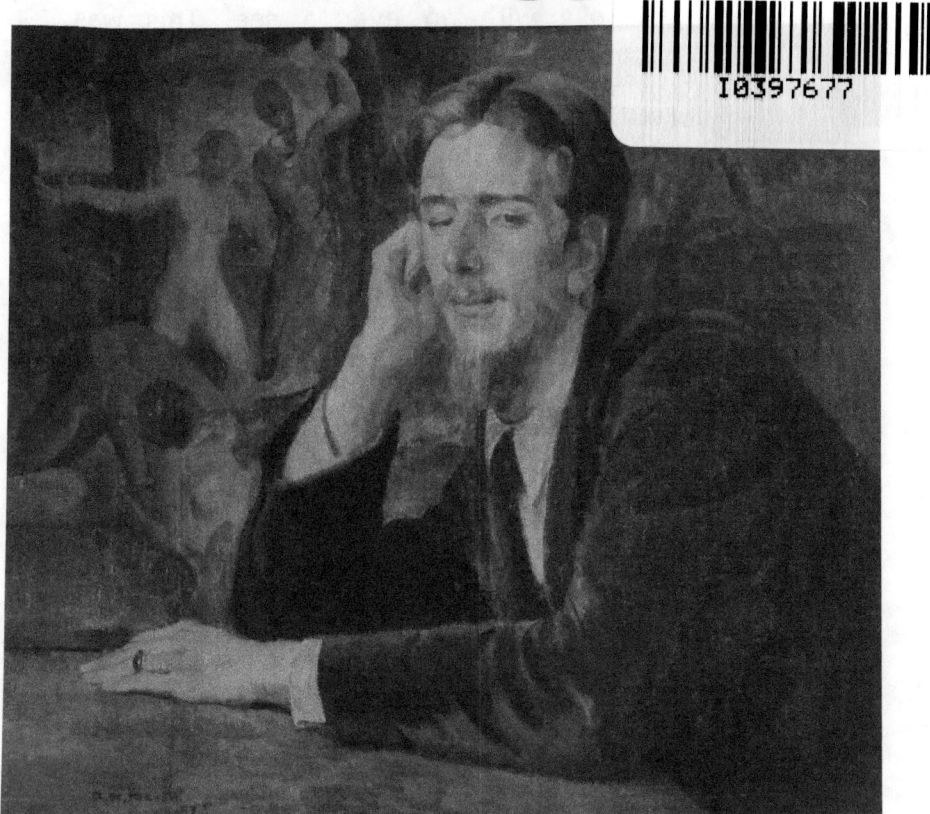

Lionel Ellis in his Studio

By Arnold Henry Mason RA (1885-1963)
Signed and dated 1927
Oil on canvas, 62 x 75cm

Introduction

Sometimes, when looking at an aged portrait one senses that the essence or spirit of the sitter is imbued in the canvas, captured for posterity, patiently waiting for those with an eye to see. This was certainly the case when I acquired the mysterious portrait of Lionel Ellis, painted by his friend and fellow artist Arnold Henry Mason in 1927. Keen to learn more about the person behind the enigmatic smile, I embarked on a journey of discovery which revealed a remarkable episode in local art history, an untold story of a prodigious talent.

The purpose of this modest monograph is to tell that story, and particularly to draw attention, for the people of Plymouth and Devon, to the fact that a true masterpiece lies within their midst. The work to which I refer is Ellis's portrait of Jeanne, which is in the collection of the Plymouth Museum and Art Gallery. Behind the portrait of Jeanne is a very human story, one which involves love and tragedy in equal measure, but I'll say no more and spoil the story which will unfold in the course of this short publication.

I hope that the reader will agree with me in concluding that Lionel Ellis should be celebrated in the city of Plymouth, and that "Jeanne" should be seen in a new light, and put proudly on permanent display.

David E Carter

In 1928, at Sir Joseph Duveen's British Artists' Exhibition at Plymouth, a local artist received particular praise. Sir Martin Conway, Chairman of the exhibition, said: "We have the enormous satisfaction of having revealed a young artist whose future may be as great as that of any artist who has ever lived."

Many artists have hailed from Plymouth. Joshua Reynolds, the famous 18th-century portrait painter and first president of the Royal Academy was born in Plympton, and more recently artists have included Beryl Cook whose paintings depict the culture of Plymouth and Robert Lenkiewicz, who lived in the city from the 1960s until his death in 2002. In addition, George Passmore, of the Turner Prize winning duo Gilbert & George was born in the city. But who was the young prodigy whose 'discovery' in 1928 caused a sensation and led to him being hailed as a future Rembrandt?

A Western Morning News article in February 1928 provides the answer:

It must be a source of gratification to the people of Plymouth to find that the outstanding feature of the exhibition is the

product of local talent. It is true that there is nothing particularly "modern" in Mr. Lionel Ellis's "Jeanne", a three-quarter length study of the nude, but neither is there anything academic or lifeless. Mr. Ellis received his first instruction at the Plymouth School of Art. He subsequently attended the Royal College of Art. But a glance at this superbly modelled figure, at the quality of his paint, and at the quiver of life that lingers about her subtly-smiling features, suffices to show that his real school was the National Gallery and that he hails Titian, Tintoretto, and Leonardo da Vinci as his masters.

Western Morning News, February 1928

The Yorkshire Post also reported in March 1928:

YOUNG ARTIST

ENGLISH "DISCOVERY" AT AN EXHIBITION

"Jeanne", the striking "nude" by Lionel Ellis, the young painter whose "discovery" is the sensation of Sir Joseph Duveen's British Artists' Exhibition at Plymouth, has been bought and presented to the City's Art Gallery by a local resident who wishes to

remain anonymous.

Art critics have been unanimous in recognising Mr. Ellis's work as a remarkable achievement, and Sir Martin Conway, the Chairman of the British Artists' Exhibitions, said: "We have the enormous satisfaction of having revealed a young artist whose future may be as great as that of any artist who has ever lived."

Lionel Ellis - he is not yet 26 - studied mainly under Professor William Rothenstein at South Kensington, and later spent some months in Rome, where, as his picture shows, he came under the influence of Leonardo.

It is Mr. Ellis's intention to devote the proceeds of the sale of his picture to reopening his studio in Chelsea, where he will begin work on the portrait of the Hon. Phyllis Astor, commissioned by Lady Astor at the opening of the Plymouth Exhibition.

(Professor Rothenstein is a native of Bradford, and from 1917 to 1925 was Professor of Civic Art in Sheffield University. During the war he was one of the official British artists at the front, and in 1920 he became Principal of the Royal College of Art,

South Kensington. His own pictures here gained for him international fame).

Yorkshire Post, March 1928

Lionel Ellis was the young painter who had leapt to prominence. An article in the Western Times, March 1928, reported on the acquisition of his portrait and his first notable commission:

Famous Picture for Plymouth

The striking picture "Jeanne" a nude figure by Lionel Ellis, which was shown at Sir Joseph Duveen's British Artists' Exhibition at Plymouth, has been purchased and presented to the city's art gallery by a resident, who had expressed the wish to remain anonymous. Mr Ellis is not yet 26, and his work has been recognised by critics as a remarkable achievement. He has been commissioned by Lady Astor to begin work on the portrait of Hon. Phyllis Astor.

Western Times, March 1928

It was also in March, 1928, that Plymouth's claim to the discovery of Lionel Ellis was robustly defended by the Western Morning News, who reported thus:

Who Discovered Lionel Ellis?

Plymouth's claims to the discovery of Mr. Lionel Ellis, the artist, are being disputed by Bradford, which bases its claim on the purchase of a portrait in pencil - "Jeanne" is its title - by the municipal authorities when it was exhibited in that city last year under Sir Joseph Duveen's scheme to encourage the lesser known British artists. Curiously enough, it is only after 12 months that Bradfordians have thought fit to broadcast their claims, when Mr. Ellis's future as a brilliant artist is assured, and after the expression of Sir Martin Conway to that effect. At the time of the purchase the municipal authorities were not so sure of Mr. Ellis's talents, for according to a Bradford critic it was only after mature consideration that they "took the plunge." In the minds of West Country folk, Mr. Ellis's capabilities have never been doubted. He was born in their midst, studied with them, and on showing a leaning towards art, was encouraged by them. While being somewhat amused at Bradford's claims, they will nevertheless appreciate that the city recognises Mr. Ellis as one of our coming artists. Mr Ellis, incidentally, is reopening his

studio in Chelsea, and will begin work on the portrait of the Hon. Phyllis Astor, commissioned by Lady Astor at the opening of the Plymouth exhibition.

Western Morning News, March 1928

So there we have it, a local artist plucked from obscurity, thrust into the limelight, with multiple commissions, heaps of praise and a London studio from which to develop a lucrative living.

Ellis's art was founded on the romantic tradition of the Old Masters, and his discovery, future events and eventual fate were no less romantic. His portrait of Jeanne, which was gifted to the Plymouth Art Gallery in 1928, is still in their collection. The sitter was Miss Jeanne Bellon, herself an artist, who Lionel Ellis married in 1929 at the Kensington Registry Office, London.

The only known portrait of Ellis (apart from a much later self-portrait) was painted in 1927 by the renowned modern British painter Arnold Henry Mason R.A. (1885-1963). Interestingly it depicts Ellis in the year before his "discovery" and some 12 to 24 months before his marriage to Jeanne, in a mischievous pose with a wedding ring

poised, but not firmly placed on his finger. The exact narrative has been lost with the passage of time, but his sly grin, together with the mysterious wedding band, raise the likely scenario that the portrait marks his engagement. The background is one of Ellis's own erotic 'Rubanesque' history paintings (a fragment of which still exists). Arnold Henry Mason was a prominent portraitist who shared a London studio with Augustus John.

Ellis was born in 1903 and studied at Plymouth School of Art from 1918 to 1922. From 1922 to 1925 he studied at the Royal College of Art, and from 1925 a travelling scholarship took him to Colarossi's in Paris, and also to Florence and Rome. The 1927 portrait of Ellis would suggest that he mixed with the 'Slade' group of Modern British artists in London from circa 1925.

Ellis's first notable commission was reported in the Western Morning News in December 1928:

WOMEN IN PUBLIC LIFE

LADY ASTOR AND FIGHT AGAINST PREJUDICE

Dame Millicent Fawcett, the veteran pioneer of the Women's Movement, was presented last night with a portrait of herself painted by Mr Lionel Ellis, a young British artist. The presentation, which was made by the National Union of societies for Equal Citizenship and the London and National Society for Women's Service, took place in Lady Astor's London house. Speaking of the future of women in public life, Lady Astor said. "I think it will be a long time before women can have a real career in the House of Commons because there are so many years of prejudice to fight against".

Western Morning News, December 1928

A later news article (Western Morning News, October 1930) which recalled Ellis's discovery, is revealing as it mentions his lowly circumstances:

Behind the nude painting of a woman, "Jeanne", by Lionel Ellis, which hangs in the exhibition, is the story of an artist who was rescued from poverty. When the picture was exhibited at Plymouth it created a sensation, and the artist was hailed as a future Rembrandt. A search was made for the 25 years old artist, who was found on the verge of starvation. As a result of the publicity he

received commissions to paint a number of portraits, which set him on his feet. The figure in the picture, which has a smile faintly resembling that of the Mona Lisa, was at first regarded as a copy of an old master's work, but turned out to be that of the artist's fiancé.

Western Morning News, October 1930

In 1930 Ellis had his first work accepted by the Royal Academy, as reported by the Western Morning News, May 1930:

Three artists who received their early training in Plymouth art schools had had their pictures accepted by the Royal Academy this year - Lionel Ellis, Donald Floyd, and Francis Hodge, of whom the city was proud, and at whose success they were delighted.

Western Morning News, May 1930

Later in 1930 Ellis exhibited works in a mixed show at London's Guildhall.

Western Morning News, October 1930:

WESTCOUNTRY ARTISTS' WORKS AT LONDON GUILDHALL

The loan exhibition of works by living British artists, arranged by British Artists' Exhibitions, founded by Sir Joseph Duveen, Bart, was opened at the Guildhall Art Gallery by Prince George, who, in the course of his speech, mentioned that the works are the personal choice of people like himself, fond of art, who like to see pictures of English life and landscape. The collection included four works which Prince George purchased at a sale exhibition at the Glasgow Art Gallery last year.

The following west country artists have work which has been lent for the present exhibition - Gladys Best, Topsham; Mary Duncan, Paul, near Penzance; Lionel Ellis, late of Plymouth; D H Floyd, late of Plymouth; Hester Frood, Topsham; S H Gardiner, Lamorna; Reginald Hamlyn, Plymouth; Gertrude Harvey, Newlyn; Harold Harvey, Newlyn; F G Heath, St Buryan; Francis Hodge, late of Plymouth; R Morson Hughes, St Buryan; Mary McCrossan, St Ives; R J Enraght Moony, Truro; Borlase Smart, St Ives; Helen Stuart Weir, St Ives; and S M Whitham, Combe Martin.

Western Morning News, October 1930

In April 1931 Ellis held a solo exhibition at the Redfern Gallery in Old Bond Street. An article in the Dundee Courier reported thus:

FROM PAVEMENT TO GALLERY

FARM LABOURER WHO BECAME ARTIST

A man who was once a farm labourer and then became a pavement artist in Trafalgar Square is to hold an exhibition of his works at the Redfern Galleries, London, next month. He is Mr Lionel Ellis, of whom Sir Martin Conway has said - "His future may be as great as that of any artist who has ever lived." From his earliest days his great desire was to be an artist, and in spite of the hard work he had to do as a boy - he is still only in his late twenties - he found time to practise his hobby. From the Plymouth School of Art he won a scholarship to the Royal College of Art.

"This was only £50 a year." he said in his Kensington studio yesterday, "and I had to struggle to live. So I became a pavement artist in Trafalgar Square. I made enough money in this way to supplement my scholarship allowance. "There will be nothing modern about my exhibition. I have been

constantly startled by the slapdash methods of many modern artists, whose laziness prevents them from taking the pains to acquire proper technical foundations".

Dundee Courier, April 1931

In September 1931 Ellis exhibited at the Ferens Gallery, Hull.

Hull Daily Mail, August 1931:

Three fine oil paintings by an inspired pavement artist will be among the interesting features of the Autumn exhibition which will open in the Ferens Art Gallery early in September.

Lionel Ellis is one of the most romantic figures in the art world at present. He did not begin "on the pavement", but was driven to it by the pinch of necessity. He is still only in his twenties. Down and out, he was working on the flagstones of London streets when the merits of his work were noticed by connoisseurs. Through their interest he was able recently to hold a show in Bond Street. But it is to the pavement that he returns when he wishes to make money.

"His style is not what is superficially termed

modern," says Mr Vincent Galloway, Director of the Ferens Gallery. "It is more like that of the old school, with perhaps a greater vigour of outlook. He sometimes copies the style of the old Italian masters. The three pictures which are coming to Hull are 'I will make you fishers of men', 'Asleep', and 'Perilla'".

Hull Daily Mail, August 1931

Hull Daily Mail, October 1931:

Lionel Ellis, the pavement artist who has graduated to Bond Street, but returns to the kerb-stone for his living, shows "Perilla" (9) and "Asleep" (2) and in the second gallery a still finer work "I will make you fishers of men" (40).

Hull Daily Mail, October 1931

One of Ellis's more unusual commissions was for a large mural at a cafe in London, reported by the Western Morning News in June 1932:

Plymothian's Mural Art

Mr Lionel Ellis, the clever Plymouth artist, has just completed a striking piece of work at a cafe in Oxford Street, where he has

executed a fine mural painting covering the whole of one wall and measuring 16ft. by 6ft. 6in. The large airy room of the cafe lends itself especially to this kind of decoration, and it need hardly be added that Mr. Ellis has made the most of his opportunity. He tells me that he was asked by the director of the restaurant to work out a scheme in which the dominant ideas were to be repose and harmony, as an antidote to modern noise and bustle, and these ideas were to be expressed in terms of sunlight, space and human beauty, while food and drink should not be unduly stressed. The result is what might be described as a classical picnic party, although I hasten to add that the description sounds almost reprehensibly frivolous.

How Design was Conceived

"I conceived my design," said Mr Ellis, "while watching the 'Silver Lining', an outstanding film, shown some months ago in London. Rain lashing across a window partly covered by a lace curtain, with the drops trickling like music down the pane, suggested the harp theme upon which the composition is built, with its variations right through the decoration." The painting has been done

during the week-ends for the past five months, and many habitees of the restaurant have had the unusual experience of watching the growth of the picture from week to week, while, on the other hand, Mr. Ellis has had the diversion of quite a number of amusing conversations with people anxious to assist with hints and criticisms, helpful and otherwise. On the whole, he took the philosophic view that no task could be happier than the making of public decoration.

Western Morning News, June 1932

After 1933 there is little mention of Lionel Ellis. He is known to have exhibited from 1927 to 1933, which certainly marked his busiest period. In addition to his oil paintings, he was a noted wood engraver and book illustrator. He contributed 100 engravings, many in period erotic form, to "The Complete Poetry of Gaius Catullus Comprising the Satyricon and Poems" (London: Fanfrolico Press, 1929). However, his name does surface again in the resumes of several noted artists as a master at Wimbledon School of Art, from the late 1930's through to the 1960's. We can therefore surmise that Ellis in all probability decided to concentrate his efforts on

teaching art. His flirtation with fame was very real, albeit fleeting, and one can only wonder what might have been, had he taken a different turn in his career.

Ellis's story is at once moving, mysterious and romantic. The headlines tell us of a talented pavement artist who touched fame and slid back into obscurity. The art dictionaries tell us practically nothing about the artist, and too few of his works survive to form a meaningful oeuvre from which any information might be derived. We do know that he made the decision to take up teaching at the excellent Wimbledon School of Art, although we are left to wonder - why?

What drove him as an artist, what was his inspiration, his ambition? These are all questions that can be answered, thanks to an in-depth interview with Ellis published in the Western Morning News, in June 1931.

ART TRADITIONS OF THE PAST

RESTORING OF POST IMPRESSIONISHM

INTERVIEW WITH RISING PLYMOUTH ARTIST BY OUR LONDON CORRESPONDENT

I had an illuminating talk recently with Mr

Lionel Ellis, the clever young Plymouth artist, whose successful career is being so keenly followed by many of his fellow citizens. Mr. Ellis is a man of very decided opinions, which he is not afraid of expressing, at any rate where his art is concerned, and while, like all clever people, he is bound in the natural course of things to display his own individuality in his work, he strongly deprecates anything in the nature of freak originality or the foisting upon the art-loving public of what he considers are in many cases nothing more than personal idiosyncrasies.

"GENIUS AND "INSPIRATION."

"We are in the habit," he said, "of attaching superhuman powers to creators of all types, and, to explain their abnormalities, we invent the meaningless words "genius" and "inspiration". These indefinite terms change their values as human perception grows. The theories to which Euclid devoted his life are now the common property of schoolboys".

"But do you not consider," I suggested to him, "that all art is inspired?"

"To an extent," he replied. "But we may say that only one artist was not derivative. His name, however, is lost in antiquity, and from the time the first cave man made the first drawing all art has been imitative. It would be preposterous to ignore all that has been done, as every painter would then have to begin in exactly the same place, and art could never progress."

"Do you think ultra-modern art can be called merely imitation then?" I asked him

MODERN IDIOSYNCARASIES

To that, he observed, "At the present day we are accustomed to seeing our contemporaries straining to display their idiosyncrasies - all those trifling details in which they depart from their fellows - but in the main they merely achieve the same end in monotonous nausea, as their idiosyncrasies are, after all, much about the same.

"They banish from their perceptions all that has been done, at least prior to Cezanne, because merely to repeat the past entails no small labour. They attempt to acquire a childlike simplicity, but too often they only

succeed in being childish. It is more modern to imitate Cezanne than Titian, but hardly more original."

TRUE ARTIST'S INDIVIDUALITY

I propounded to him the problem. "What is the attitude of the true artist towards originality?"

His reply to that was prompt: "Just as the inventor makes wise use of all the material of the past, so the artist is not afraid that his individuality will be submerged by the influence of other masters.

"It is true the mediocre artist will lose his personality, but it is obviously not worth retaining, and he will remain in his mediocrity. The great artist will be so much the stronger for absorbing the merits of his predecessors.

"In the Sixth Discourse Sir Joshua Reynolds said: "Even genius is the child of imitation." Raphael did not close his eyes to the merits and excellences of his great contemporaries, Michel Angelo and Leonardo, but sought to combine their strength and add a sweetness of his own.

21

NOT SO JEALOUS THEN

"Tintoretto inscribed over his studio door the words: "The design of Michel Angelo and the colour of Titian." They were not so jealous of their individuality as the painter of the present time."

"Or is it," he added slyly, "that only by careful nursing modern painters can preserve their uninteresting personalities - descending even to the extravagance of producing ugliness."

"To what basis cause would you then attribute the triumphs of the old masters? I asked him.

"The aim of the old masters," he declared, "was to create out of the accidents of Nature a universal beauty - "the thing not as it is, but as it should be," as Aristotle defined it - the creation of a pictorial symbol of the universe. In this ideal the reaction of the individual to the world can play no valuable part."

IMPRESSIONISM

When - as we were parting company - I broached the question of his own individual contribution to the progress of art, Mr. Ellis replied: "To attempt to restore the great tradition of the past, broken by Victorianism, Impressionism, and Post-Impressionism, is no easy task, and is a task that will not be appreciated by superficial examination. But this is my ambition.

"If I am called an imitator, I say that all art is imitative, and all painters must be put into the same class.

"To define eternal truth is not so easy as to display one's eccentricities. Nor is it so profitable."

Western Morning News, June 1931

What drove Ellis as an artist, what was his inspiration, his ambition? We may now find answers for these questions. Ellis had received a classical training, he was inspired by the Old Masters, his ambition was to restore the great tradition of the past. However, he lived in a world where modern art was in the ascendency, where works by the Old Masters were becoming unfashionable, so what better way to sew the seed in a future generation of artists

than by teaching?

One of Ellis's students was the artist Graham Hewitt, who studied at Wimbledon Art School and at Leeds College of Art. It was at the former that drawing tutors Lionel Ellis and David Poole, placed a high value on draughtsmanship as the basis for all creative visual work. He sums up the ethos that was no-doubt taught by Ellis, thus: Drawing is the basis of all painting, sculpture, architecture and every conceivable form of design. It is not an optional extra. Anyone claiming to be a visual artist must, by definition, be able to draw no matter how abstract or conceptual the end product might be. There is no substitute for drawing: no beguiling technique or instant digital effect can disguise the lack of it. Without the hand to eye co-ordination which drawing demands, visual art is an empty vessel.

Graham Hewitt remembers Lionel Ellis:

I remember being told by one of the masters at Wimbledon (not as it happens by 'MR' Ellis as we always respectfully called him, or 'old Ellis' when we were talking amongst ourselves - but by one of his colleagues) that Cezanne just couldn't draw: this in order to

explain the planar discontinuities and varying view points deliberately structured into a still-life of Cezanne's which I particularly admired. The words, although not those of Lionel Ellis, could easily have been his.

At Wimbledon under the leadership of Gerald Cooper RA, the approach to drawing was firmly based on a classical concept of perfect form, the depiction of things not as they are, but as they ought to be according to some platonic ideal: the production through the medium of drawing and painting of 'that which lacks nothing and from which nothing can be taken away'.

Mr Ellis - who incidentally always addressed his students as 'Mr so and so' or 'Miss whatever' - taught anatomy aided by a skeleton, numerous plaster casts of antique statuary, the male versions of which usually featured fig leaves, and a life model, most often female but occasionally a male, who always sported a jock strap or swimming trunks. He was a brilliant draughtsman in the style of Leonardo or Michelangelo and would often bolster our pedestrian efforts with examples of his own skill and knowledge. He gave us a tremendous respect for the ethos of the Renaissance masters, their quest not

just for harmony and perfection, but for structure and understanding.

Mr Ellis himself was a rather intimidating figure, but could be very humorous, occasionally sarcastic but more often quizzical and sardonic. He enjoyed a very good relationship with the students as a whole and we respected and liked him. He used to wear a tweed jacket which smelled of the horses he was known to keep. He was also reputed to have a pet fox and this no doubt added to the rich odours which wafted into the life studio as he entered.

It was rumoured that he had lost his right eye in some sort of accident involving a horse. (It's interesting to note that in the portrait of him as a young man this injury was already apparent). Due to this impairment he had the habit of tilting his head backwards and looking down his nose at whoever he was addressing, which was in itself quite intimidating, but which also suggests that his vision may have been quite seriously affected as he got older. Could this be the reason he opted for the security of teaching rather than a more precarious career as a practising artist?

There was so much that was hugely important taught to us by Mr Ellis and his colleagues and which seems to be absent from most art education these days. It was not just skill or technique, but more a way of seeing and of thinking about the world in visual terms. Outside of Oxbridge and the redbrick universities it was probably the best liberal education to be found anywhere, and I feel deeply indebted to them for the experience.

Mr Ellis's belief that the only original artist was the first one is absolutely true. But it also needs to be said that with the exception of one or two of the younger staff, he and his colleagues were imprisoned by the past. Their huge and justifiable respect for the masters blinded them to virtually all avant garde art. The comment about Cezanne with which I started sums this up. Munning's famous drunken retirement speech to the RA would have been cheered by them to the rafters. In fact it is very likely that Gerald Cooper and Lionel Ellis were actually present and applauding on the occasion. But none of this detracts from the education they provided us with. I would a thousand times rather be taught the techniques and philosophy of the masters than how to

network with today's gallerists and curators, and how to convince them and others and probably above all oneself that anything can be art if you choose to call it that.

Other ex-Wimbledon students who remember Ellis include sculptor Janeve Bainbridge and artist Robert Pengilley. Janeve remembers Ellis as a formidable, larger-than-life character, very much from the same mould as the ebullient Alfred Munnings. She remembered that he did keep a pet fox and was a keen horseman.

Robert Pengilley, is a very well established artist, now living in Australia, and he remembers Lionel Ellis thus:

As students at Wimbledon we were fortunate to have an array of talented and enthusiastic teachers. The principal, Gerald Cooper, an accomplished flower painter in the manner of the Dutch still life masters, and Lionel Ellis, both of whom could be mentioned in company with their respective 'masters'. For Mr Ellis, his ardent attachment was to one of England's greatest artists, George Stubbs, and the renaissance giant, Michelangelo. On reflection I am quite convinced they were on a similar aesthetic plane, although time

separated them, they seemed infused with the same spirit. Their identities were in stark contrast to many other staff members, who, being much more in the 20th century regarded them as somewhat out of touch. At that impressionable age, as a student given to copying the old masters, I felt a certain degree of awe. When in the presence of Messrs. Cooper and Ellis one felt that indeed they were 'real' artists. Once, upon entering the life room I was struck by the consummate skill evident in the large scale drawings pinned up on screens along the wall, clearly these were executed by a master who demonstrated an artistic ability and scientific inquisitiveness characteristic of Stubbs and Michelangelo. A striking and imposing figure in posture and gait, the monocle and Van Dyck beard, Mr Ellis would himself have made a suitable model for the life class! The insistence on study of the form was a constant feature I recall. Inclined to make quite profound and rather dogmatic pronouncements on that which constituted great art, as distinct from the mundane, such was the effect on a student it could be visibly dramatic! Given At times to an incisive wit, his eccentricities were not always well received, e.g. when he brought a sheep to the drawing class, at the end the

day's activities the cleaner was confronted with the onerous task of cleaning up, which he refused! Looking back on that era, the effect of such gifted men, their work as practising artists coupled with integrity as educationalists, has been a formative influence on my artistic endeavours, after all, the learning process goes on! Years later, as reported in the press at the time, Lionel Ellis was standing resolutely, armed with shotgun at the entrance to the rural haven he so loved, defiant in opposition to the proposed construction of a motorway that would destroy it.

The hitherto untold story of Ellis's life can be tentatively summarised thus:

- 1903: Born.
- 1918-1922: Plymouth School of Art.
- 1922-1925: Royal College of Art, South Kensington.
- 1926: Colarossi's (Paris), Florence and Rome.
- 1927: Chelsea, London.
- 1928: British Artists' Exhibition at Plymouth.
- 1929: Kensington, London. Married Jeanne Bellon.
- 1930: Exhibited at Royal Academy and London Guildhall.
- 1931: Exhibited at Ferens Gallery, Hull, and Redfern Galleries, London.
- 1932 – c1940: Possibly at Wimbledon School of Art.

- 1940 – c1970: Wimbledon School of Art
- c1970 – 1988: Not known.
- 1988: Died (although no record of this has yet been found)

It is apparent that in the early 1930's he decided to embark on a full-time career as an art tutor, although he did continue to work as a book illustrator and as late as 1950 his flower painting "Fair Rose of France" was exhibited at the Royal Academy. A mere handful of paintings by him are known, although several are almost certainly held in private collections.

The story began with the sublime portrait of Jeanne, his future wife, which ignited interest in the artist. Almost perchance the portrait found refuge at the Plymouth Museum and Art Gallery, where it remains to this day. The museum's accession record indicates that it was a gift from the artist, but an article in the Western Morning News of 14 March, 1928, records the following:

In connection with the oil painting, "Jeanne" by Mr. Lionel Ellis, which had been acquired by Mr E E Endicott, of Willowray, Lockington Avenue, Plymouth, it was decided to apply to the purchaser for the loan of the picture over an extended period and to inform him if he

should wish to bequeath it the Corporation would be glad to accept the gift.

Western Morning News, March, 1928

It would seem, therefore, that Mr E E Endicott recognised the potential importance of the painting to the City and kindly donated it.

The portrait is the result of a flash of inspiration, some would say (and did say) a work of genius. In many ways representative of it's time and place, London in the mid 1920's, when the second generation Bloomsbury Group held sway. It exudes painterly skill and the artist's recent period of study in France and Italy is betrayed by the similarity to works by the Old Masters, who Ellis so admired. The comparison of Jeanne's enigmatic smile to Leonardo's Mona Lisa is unavoidable. A portrait captures a moment in time and is imbued with the personality and aura of the sitter as seen by the artist. In this case there is clearly a romantic connection between sitter and artist, and it is no surprise that they were married soon after the portrait was painted.

But who was the beautiful Jeanne Bellon? We have so far pieced together the life of Lionel

Ellis, like a living jigsaw puzzle where several pieces remain to be found. The answer to this question might never have been known, but the chance discovery of a fascinating archive of material by her daughter, Cressida Lindsay, provides us with some interesting insight.

The Mysterious Jeanne Bellon - A Candle in the Wind...

Cressida describes her mother thus:

According to her birth certificate, Jeanne was born Winifred Munday on the 16th of October 1904. I think it was Jack Lindsay who said you could see she was a disaster waiting to happen, but she was totally without guile or malice, generous to a fault.

She called herself Jeanne Bellon, Jeanne Byron, Baroness Bracken, (presumably when she was with the Irishman who called himself Raymond, Count l'Bracken, Earl of Thomand). She became Jeanne Ellis when she married the painter Lionel Ellis, Jeanne Lindsay when she married Philip and she also calls herself Jeanne Glidewell in some of her correspondence.

The impression I get of her is that she was the original "Candle in the Wind".

Source: http://cressidalindsay.org

Cressida Lindsay (1930-2010) was the daughter of Philip Lindsay and Jeanne Ellis. One can deduce, from her year of birth, that she was involved with Lindsay soon after her marriage to Ellis. Interestingly, Philip Lindsay and his brother were in Ellis's circle for many years. Philip Lindsay was a historical novelist and a close friend of Dylan Thomas. His brother was Jack Lindsay, who founded the Fanfrolico Press for fine publishing, for whom Ellis provided illustrations for many of their publications. Philip and Jack Lindsay were sons of the Australian painter Norman Lindsay.

As an infant, Jeanne had been left in an orphanage in Jersey, had run away at a very young age and joined a circus. In her early twenties she saved up enough to get to London where she became an artist's model and was taken up by some famous painters of the time. It was through them (and Lionel Ellis) that she met Philip Lindsay.

Her life consisted of numerous relationships, her lover in the 1940's was Tom Geraghty, a

script writer from Twentieth Century Fox. For a while she mixed in salubrious company, with film stars of the day, including Charlie Chaplin, Charles Laughton and Douglas Fairbanks, yet at other times her circumstances were reduced to dire poverty.

Cressida remembers her parents thus:

They were so poor they could not afford to keep me when I was born, besides, feeding a baby would in no way enhance my mothers modelling career. For a few shillings a week I was sent away to a wet nurse somewhere in the country and from then on I spent a large part of my childhood at the mercy of strangers. It wasn't until my father published a book on Henry the Eighth which was filmed that they had me back. They were halcyon days for them and for me, with famous stars of the time for company and the best of hotels to live in. Private Life of Henry the Eighth was mostly filmed at Hampton Court and I would spend hours in the small fairground there riding the ponies.

For Jeanne it must have been the height of all her dreams. In company of Korda, Charles Laughton and the entourage of crew and script writers she glowed and for a while

we were swept into a world of chandeliers, cigar smoke, glossy furs and caviar. It's impossible to know whether life would have continued well for Jeanne if war hadn't broken out and put an end to our life of glamour, but the American crowd withdrew and Jeanne, bereft of her friends and one special lover, was heart broken. Her lover, Tom, continued to write to her for some years and the fact that a friend of his from Twentieth Century Fox had taken me on as a God child and had me baptised a catholic altered my destiny irrevocably.

Courted by many for her beauty and natural charm my mother drifted away from my father. I know none of the details but Jeanne was totally out of her depth with a child and I was sent away again. Her love for alcohol was beginning to catch up with her, though not too noticeably, as during one of my sojourns away she married an Irish Earl and for a while we went back to a life of Riley. Unfortunately he was a Nazi sympathiser so we had to move around a lot. She found us in bed one day, though I'm pretty sure nothing much had happened all hell broke loose and we were on our own again, but not for long because Jeanne's drinking took off, until we were finally separated and I was

made a ward of court.

I heard much later that she had married again but unfortunately he died and she went steadily down hill.

Source: http://cressidalindsay.org

Courted by many for her beauty and natural charm...

The brief but poignant tale of Jeanne's life certainly fills a void in our quest, and the above phrase, coined by Cressida, seems particularly relevant. Her union with Lionel Ellis was short, but no-doubt intense. Their break-up would have occurred around the time of his last known exhibition, and some years before we pick up the thread again and find him teaching at Wimbledon.

We can only speculate on the effect that the cessation of their relationship might have had on him, did he take it in his stride, or did it have a lasting effect on him? The portraits featured in this narrative both hold strong clues which suggest a deep affection, the painting of Jeanne is haunting, especially when revisited, in full knowledge of the

circumstances around it's creation. Arnold Mason's portrait of Ellis, at first mysterious, suddenly makes perfect sense – it portrays the sitter happy in the knowledge that he's got his girl! Devices such as the deliberately placed wedding band and the self-satisfied grin are telling as much to those with an eye to see.

There is no record of Ellis marrying again, and those who knew him in later life recall a somewhat extravagant individual, who perhaps lacked the feminine touch in his appearance - and not too many wives would tolerate the horsey odours and pet fox!

What began as a routine enquiry for me, after I had acquired the painting of Ellis, soon became a pursuit as the clues slowly emerged. There is much we still don't know about him, but I will certainly be keeping an eye out for any of his works which might appear on the market.

Lionel Ellis, Plymouth's forgotten prodigy.

Arnold Henry Mason (1885-1963)

Below is a short biography of Arnold Mason, who painted the portrait of Lionel Ellis in 1927.

- Portrait and landscape painter.
- Studied Royal College of Art and Slade School.
- A.R.A. 1940, R.P. 1935.
- Address: Oswestry 1905, London 1908 and 1918, Ludlow 1913.
- Exhibited: Chenil Galleries 6, Glasgow Inst 1, Goupil Gallery 7, International Society 1, Walker Art Gallery 5, Leicester 11, London Salon 6, Manchester 2, New English Art Club 16, Royal Society of Portrait Painters 35, Royal Academy 38, Royal Institute of Oil Painters 3.
- Helped Sir William Richmond with decorations at the Old Bailey, London, 1906-8.
- Served in the Artists' Rifles, 1915-1918.
- Exhibited at the RA from 1919, being elected RA in 1951.
- Showed at NEAC, RP, Leicester Galleries, Goupil Gallery and ROI.
- Examples of his work are in the collections of the Tate Gallery, Manchester City Art Gallery and Wakefield City Art Gallery.
- Earned his living mostly by painting portraits, much in the style of Augustus John, with whom he shared a studio.
- Engaged to fellow Slade artist Winifred Knights and produced a number of remarkable portraits of her.

Credits

I would like to say a special thank-you to Graham Hewitt, Janeve Bainbridge and Robert Pengilley for providing a fascinating insight to Ellis's time as a tutor at Wimbledon Art School. It is refreshing to see that his talent and passion influenced a future generation of artists.

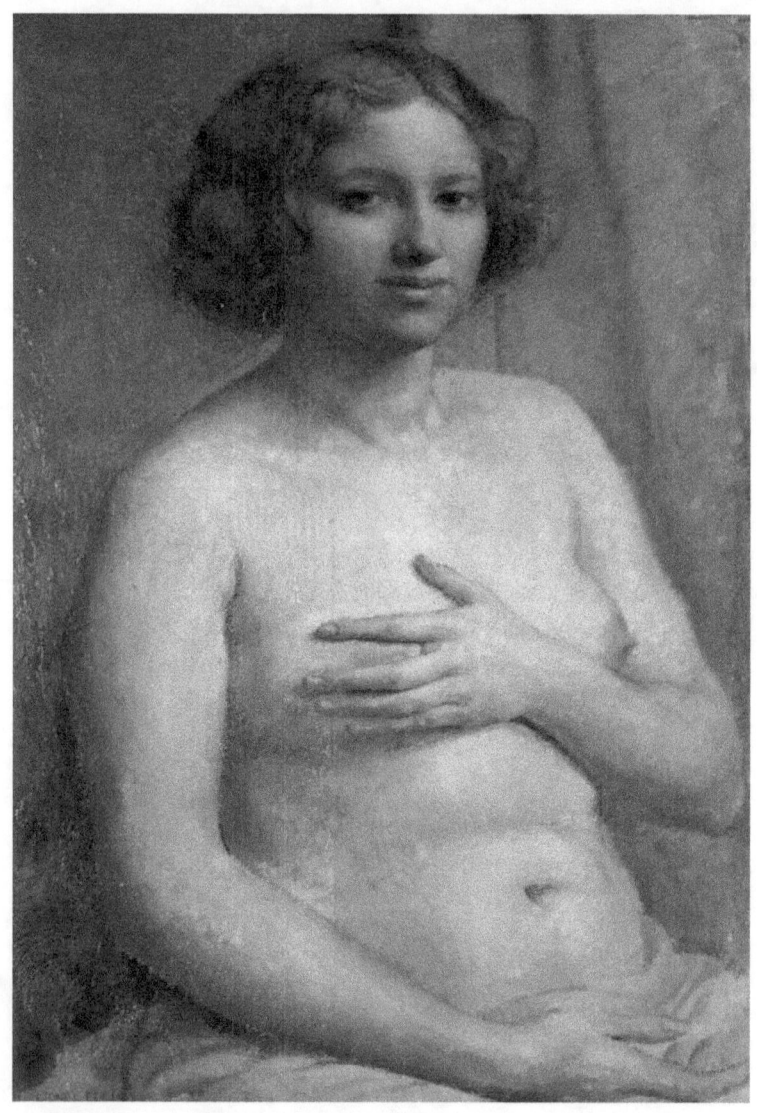

Jeanne, by Lionel Ellis
(Plymouth City Council Museum and Art Gallery)

www.ingramcontent.com/pod-product-compliance
Lightning Source LLC
Chambersburg PA
CBHW072304170526
45158CB00003BA/1181